DATE DUE			DEC 03
GAYLORD			PRINTED IN U.S.A.

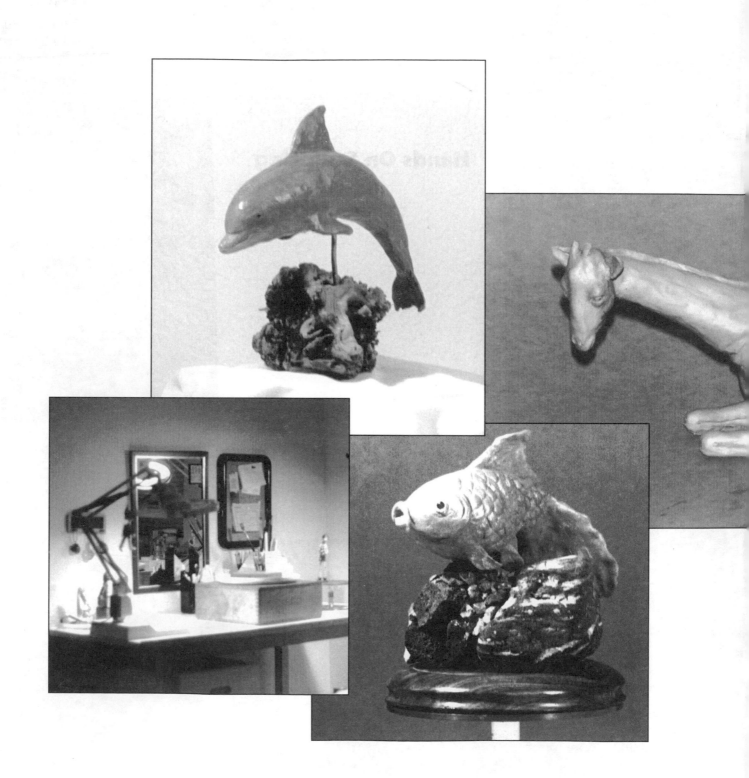

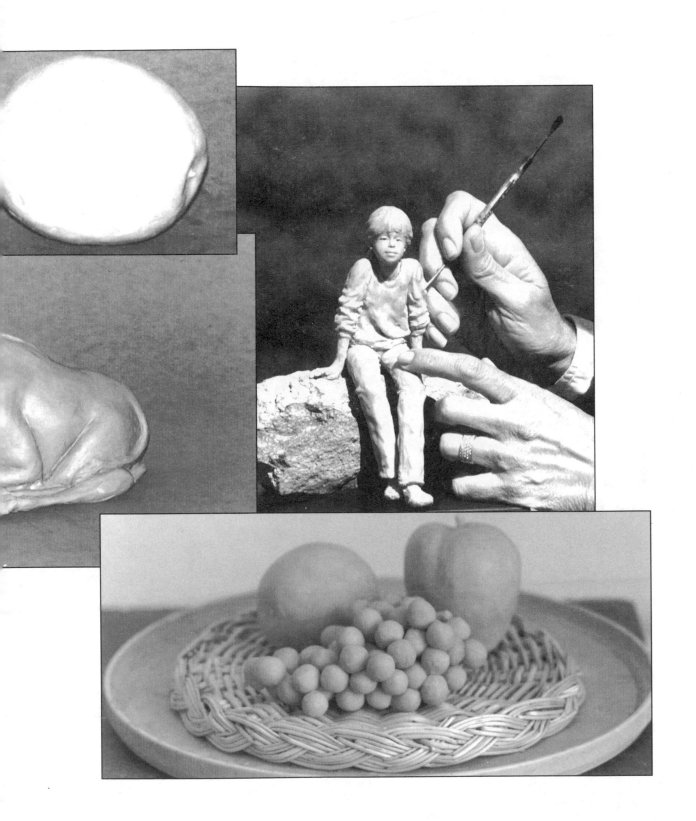

Hands On
Sculpting

Dottie Erdmann

Columbine Communicatons & Publications
Fortuna, California U.S.A.

For information, address:
Columbine Communications & Publications
1293 E. Barcus Way
Fortuna, CA 95540

Printed in the United States of America
5678910

ISBN 0-945339-51-8

Library of Congress Cataloging-in-Publication Data
Erdmann, Dottie, 1938-
 Hands on Sculpting/Dottie Erdmann.
 p.cm.
 indludes index
 ISBN 0-945339-51-8 : $19.95
 1.Sculpture --Technique.I.Title
 NB 1170.E7 1992
 731.4'2 -- dc20

 92-8529
 CIP

An Important Note from the Publisher

Columbine Communications & Publications and the author rec-
ommend that you always follow the manufacturer's recommen-
dations when using their materials. Their suggestions for firing,
degree temperatures, time for firing and use of their and other
materials with their products should always be understood and
followed. The publisher and author assume no responsibility for
misuse of materials.

Table of Contents

Dedication

This book is dedicated to my husband, Bob, for his personal encouragement and professional advice, which is second to none. And to my daughters, Kathy, Karen, Julie, Jenny, and Mary, whose unconditional admiration for my work and my effort in this book was my greatest source of inspiration. They have been superb "involuntary models," submitting to my commands to sit and stand "like this or that" over and over and have tolerated demands on their time with love and cheerfulness. I am confident we wouldn't have wanted it any other way.

Acknowledgments

I must acknowledge and thank two dear friends and fellow sculptors, Bobbi Byrd and Lois Buterbaugh, who nursed me through the creation of an "idea" until it finally met the criteria for a "book." Besides just listening to my ideas and reading my notes, both continually gave positive and constructive feedback for my next chapter.

Thank you Beverly Eastland for caring above and beyond the call of duty. While speedily typing manuscript scribbles and checking grammar and punctuation, you took the time to help organize and tie up many loose ends.

A special thank you to Ken Thoenis, ceramics instructor at San Pasqual High School in Escondido, California, and the five students he gave me for several weeks to fine-tune the projects included here. Their no-nonsense interest is appreciated. Thank you Harry, Elvia, Marcus, Jessica, and Kelly.

I also have to note the fine work and patience of Photo Dark Room in San Marcos, California, through all my trips there, especially after I dissected the contact sheets for a personal layout.

I hope everyone will accept my sketches for their usefulness, not their technique. Enjoy the book.

I remember the first day I walked into an art store for sculpting supplies. Actually, I'd hoped I'd find some tidy little kit, but this was not the case. I left with a box of clay, armature wire, and a tool, which are still the core of my existence. I knew what I wanted to do and did it, more or less. Although the result was not wonderful, something kept me working. Finally, skinny figures came to life before my eyes.

That was my introduction to the expansive world of sculpture (which means exposure to clays, wood, stone, wax, and bronze casting), to study with many talented people in the field today, and to the masters of the past.

This book has been lying as haphazard notes in a drawer for several years. The inspiration to publish surfaced from the people I come into contact with every day and from those I've met during the past 20 years while teaching classes. All expressed the desire to sculpt but shared a common problem of not knowing how to begin. I am confident that with this book I can ease you into this expressive art form.

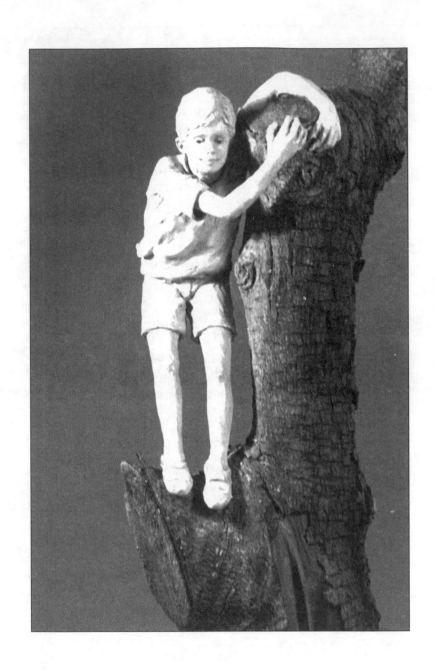

1

Welcome to the World of Sculpture

"No great artist ever sees things as they really are. If he did he would cease to be an artist."
 Oscar Wilde, The Decay of Lying

Welcome to the world of sculpture. You can begin by whittling a piece of wood or a bar of soap or, more commonly, by shaping a piece of clay, which is what we'll be doing. Included here are some easy techniques that I've developed for my needs that I think will also help you.

Since sculptors seem to be an innovative lot, you may quickly create tools and procedures to use for yourself that aren't discussed here. That's great! Feel free to improvise.

Once you've been introduced to handling clay, tools, and basic equipment, there are no boundaries.

Let's get started!

As I introduce you to sculpture, I will try to show you what a pleasant, relaxing art form this can be. You will be able to sit at a table in your home or in a small studio, unencumbered by complicated equipment and tools.

I will mention here that this is not a book on the technicalities of kiln firing, mold making, or casting since there are many excellent books written on these subjects in your local library. My goal is to get you from here to there.

The clays I work with in this book are Sculpey and Plastilena, which are discussed in detail on pages 5 and 7. They are perfectly suited to beginning sculpture and small projects because of their clean, easy-care properties. They can be constructed easily over armatures and will not air-dry. Most art stores carry both.

The main difference between the two is that Sculpey can be brought to a hardened, permanent form simply by curing in a home oven. Without curing, both can be used over and over again. At cooler temperatures they harden temporarily until worked in your hands to restore the original softness.

Sculpture is three-dimensional and thus needs to be worked on all sides simultaneously. Having a simple turntable to constantly turn your work is a first priority. You can find something suitable in a drug or discount store or through catalogs in your local art store.

I would also suggest you try to work close to eye level. It is imperative when doing portraits and much easier on your eyes and neck on any project. You can use a pedestal under your work, which you can construct yourself, or buy a raised turntable.

Don't concern yourself with many tools at first. Develop a tactile communication among your mind, eyes, and fingertips. Each project will fine-tune these senses and nurture the delicate touch you desire. I could see it happening as I worked and was as amazed as anyone! Simple shapes are the best way to begin. They often become an insightful piece of sculpture with little needed detail. In the days ahead you can move on to more detailed work as you feel comfortable. Next, start to recognize shapes as they relate to your subject. (The meaning of this statement will become clearer as we proceed.)

Another crucial aspect in sculpture is developing a sense of "seeing." The world around you every day provides background information about objects and people around you, to generally guide you through your work. Life experiences have given you emotions, which are equally important for the "why" of your pieces. But now you need to start looking seriously. Notice how shapes and masses come together, what is small in relation to something a little larger. Become aware of how a form joins another, as at arm and leg joints or ears fitting onto the head, and study folds in your clothes. This is how you'll begin to "see."

Finally, what you sculpt will be a very personal statement. Therefore, do subjects familiar to you, which you understand and with which you feel a special bond or emotion. After all, "Work not inspired from within is just another technical exercise."

At this point, I will offer several projects to teach you how to begin working with clay, so that you can comfortably find an area of interest for your satisfaction and pleasure.

For me, sculpting has been addicting, challenging, relaxing, and rewarding. I know you'll enjoy it too.

2

Materials

A product on the market for more than 20 years, **Sculpey**
Sculpey is becoming more popular with serious
artists every year but is still unknown to many.
Sculpey is a plastic, oil-base clay that will not air-
dry. This means that you can safely set it aside to
work on as time allows. I have had some cracking
in pieces exposed below room temperature, both
before and after baking, or when there's been
insufficient armature support. You'll soon learn
any limitations as you experiment on your own,
but they will be few.

When a piece is finished, bake it in your home
oven at 275° for about 20 minutes. For a piece
thicker than 1-1/2 inches, I suggest using alu-
minum foil. wood, or paper as a core for even bak-
ing and for financial practicality. A hotter oven or
overbaking, which may turn the clay brown, does
no other harm.

You must be sure when adding new clay or join-

ing sections of clay during construction of your work that the seams are completely invisible before baking. Otherwise, added pieces may not hold. I'll remind you of this frequently.

Before baking, consult manufacturer's directions on the package.

The Polyform Company, which manufactures Sculpey, offers other products under this name. Super Sculpey, a newer product, cures to a much harder, shatterproof consistency. Sculpey III is offered as small packages of colored clay.

Plastilena

Also a man-made product that's been around since the turn of the century, Plastilena is found in the studios of many sculptors who will be casting work from the Plastilena into bronze. Personally, I like the smell and love its feel, although Plastilena lacks the plasticity of Sculpey. Plastilena will not air-dry and can never be permanently cured. As I mentioned earlier, it is primarily for work that will be molded and then cast. Good molds can also be made from Sculpey pieces.

Plastilena is also packaged in bright colors for children. Of course, any of the nonhardening children's clays will work well for the projects in this book.

You can apply a protective coating of shellac or varnish over Plastilena to keep dust off for semipermanent protection, but the clay beneath will remain soft. Plastilena comes in four hardnesses:

Soft: Extremely pliable
Medium: Stronger than #1 and the most favorite consistency
Medium firm: Firmer grade for smaller objects
Extra hard: For extreme detail

**Tools and
Equipment**

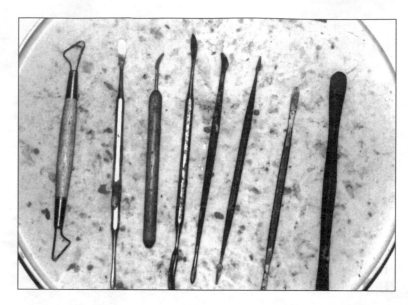

These are the main tools for my work, especially those that are spatula shaped.

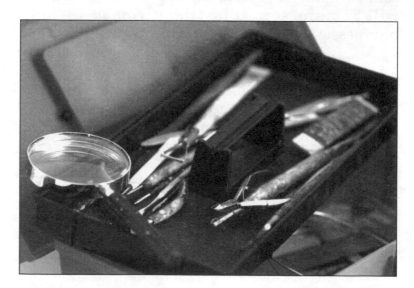

A tool box such as this is a good way to carry your supplies.

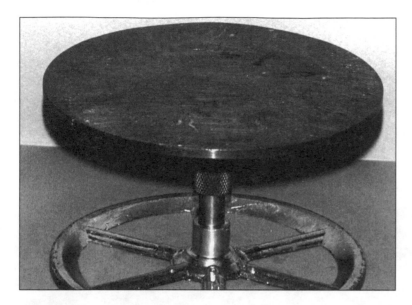

A raised turntable or banding wheel.

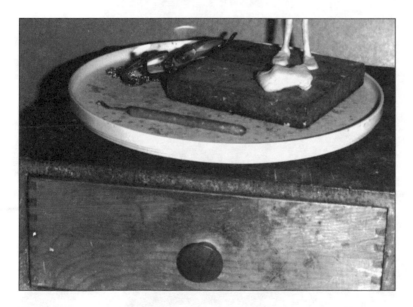

My clay box, which I've had for 20 years, and an inexpensive plastic turntable holding a typical set-up for my work.

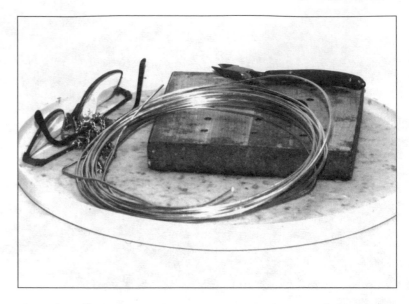

A pair of wire cutters, armature wire, and formica drilled to hold an armature.

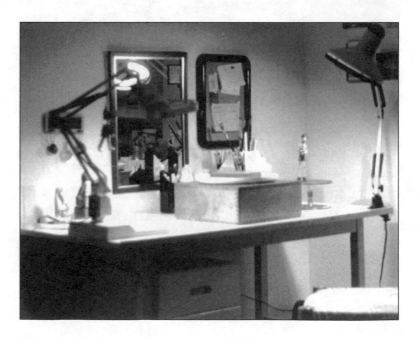

Here's all the room you need! This is my well-lighted work area.

Armatures can be all shapes and sizes, to say the least.

The armature I construct for my skinny people is a small, simple one. But a toothpick in the leg of an animal you may be doing is considered an armature as well.

You can purchase ready-made armatures made specifically for head, animal, and full human body construction.

As the work to be sculpted gets larger, the armature becomes more complicated and more heavy-duty, usually involving heavy pipe.

Armatures

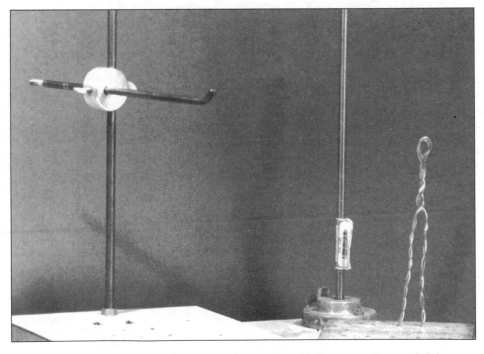

This is an armature for one of my small figures. It could be wood or formica, 5 inches square with holes drilled 3/8 inch deep, 3/4 inch apart.

"*A great artist is always before his time or behind it.*"

George Moore

3

Finishes and Patinas

Use acrylic (water-base) products only on Sculpey.
Acrylic paints are a perfect first approach on your
sculpture. Then spray or brush with an acrylic
glaze in matte or gloss. The new metallic acrylic
paints are also very convincing. I use some oil-base
products on Super Sculpey but suggest testing
first. Now and then a product will remain tacky.

Wood stains: Brush on wood stain; after a few
minutes wipe excess. When dry, apply paste wax
and polish delicately or apply a semigloss glaze.

Double-toned painted effect: Paint piece a solid
color and allow to dry thoroughly. Next apply a
heavily thinned, lighter or darker shade of paint.
Allow to set no longer than 30 to 40 seconds,
then wipe excess, leaving second color in
crevices, for a delicate two-toned effect. Mixing
with polymer medium will provide a slightly
longer working time. When dry, apply paste wax
and buff lightly.

Stone effect: Apply a terra-cotta color, paint on a thinned coat of a lighter shade, and wipe as described above. Grays are also good. Another way is to paint the whole piece gray while still wet, spray on black, then spray white lightly and from a greater than normal distance so the spray begins to dry before hitting your work. The third way is to get one of the prepared spray stone kits. After painting, apply wax and buff lightly.

Metallics: Paint clay with gold or bronze acrylic and let dry. Apply a thinned burnt umber over the gold and wipe away excess on highest surfaces. Sparingly apply a thinned coat of blue-green paint for simulation of oxidation and wipe off, again leaving only traces. Reapply a coat of thinned burnt umber and wipe off excess. Let this coat dry completely before applying paste wax and polishing. Sometimes a touch or two of gold wiped on at the end will add needed highlights. No need to worry, you can keep applying paint until you're satisfied. The wax touch is imperative.

4

Getting Started: Hands-on Sculpting

"Some sculpture is warm, some forever cold."
 Robert Henri

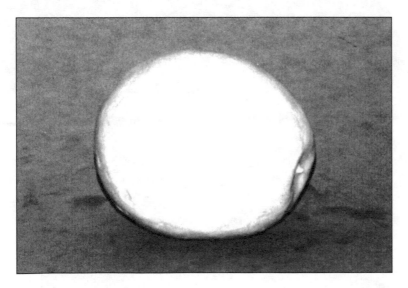

You can copy the lemon in the book or, better, use a real one.

Lemon-Aid

This is an easy assignment. Take up a piece of clay that you can comfortably fit in the palm of your hand, and roll it until softened and nicely rounded. This size should be just about the actual size of a lemon.

1. Lemons are nearly round, some more so than others. Usually the stem end is slightly smaller, and there's a definite protruding point at the opposite end. Add an extra small ball of clay for this, then work to a gentle point.

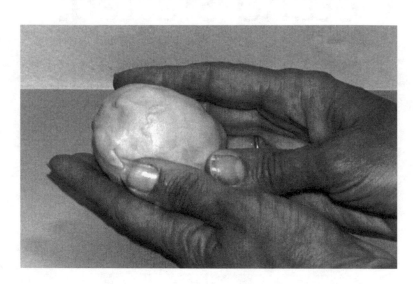

2. Starting now, if you have a lemon in front of you, turn the lemon and turn your work. Continue turning every few minutes.

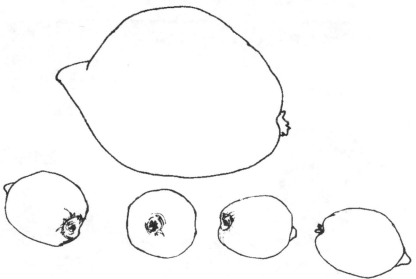

These are changing contours you'll see as you turn your lemon.

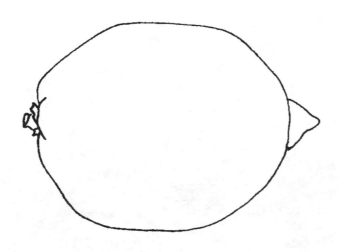

3. After looking around the entire circumference of the lemon from the side, stand over the lemon and look down over it. This shows you the shapes front to back, a new perspective. All these angles are imperative for sculpting an accurate lemon.

4. By picking up the lemon and looking straight on from the stem end, you'll see another group of subtle shapes around the outside.

5. Spend some time going from view to view until you are satisfied with your sculpture. A good idea would be to roll your sculpture into a ball and do it again or to make a still life with two or three of them!

If using Sculpey: Bake at 275° for 20 minutes.

This is an excellent exercise for beginning to "see" and exactly the same approach you'll use for everything you sculpt.

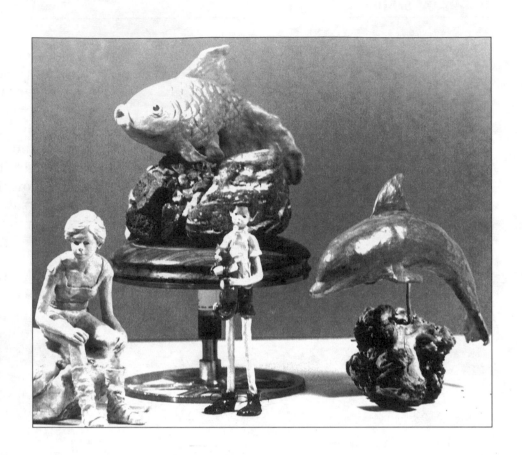

Red Delicious apples are interesting and shapely. Notice that this apple is full at the top and smaller at the base. Also, as you turn it, notice the uneven bumps around the base and the lengthwise indentations. Again, you can copy this apple or use a real one.

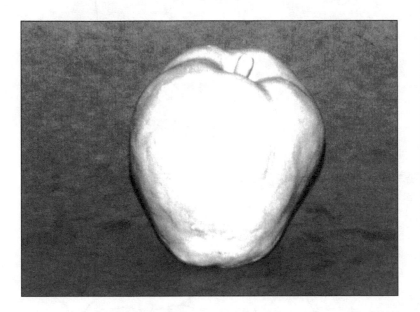

Making an Apple Out of a Lemon

1. To begin this piece, roll a ball as with the lemon, then gently put pressure on the lower end while rolling it back and forth until it starts to narrow. With your fingers, push into the clay to make the larger, more obvious indentations in the top and bottom.

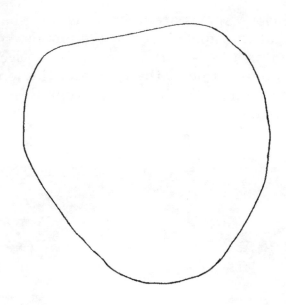

2. Before you begin working the detail around the outside, put a toothpick into both your real apple and your sculpture to mark a spot, as illustrated. It's very easy to lose your starting point as you start turning, I discovered! Keep turning each few minutes, working your way around to where you began. Working on the bottom, do this again.

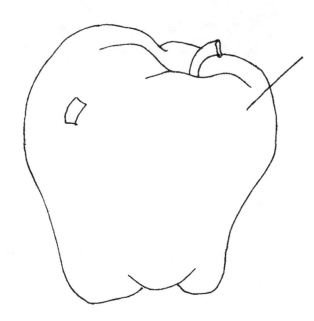

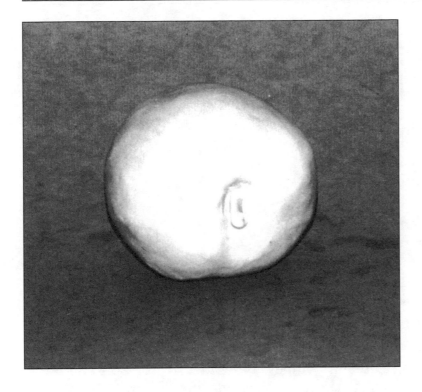

3. Now look down over the apple for circumference shapes. Carefully turn and work these shapes into the corresponding shapes at top and bottom. Gradually you will learn to simultaneously compare all these areas while working on a piece. It's like learning to drive! Look at your sculpture from the side, top, and bottom until you have your finished apple.

"Art consists in bringing something into existence."
 Unknown

4. Remove your toothpick marker and smooth over insertion area.

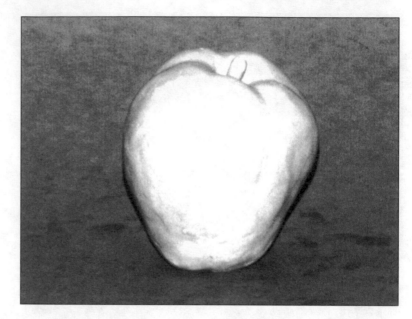

5. As a finishing touch, add the stem. Roll a small coil. Flatten the tip and press into place.

If using Sculpey: Bake at 275° for 20 to 25 minutes. If there is cracking, just fill with new clay and bake another 10 minutes.

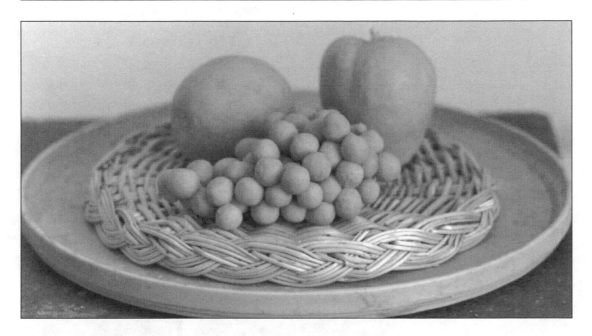

Here's a suggested arrangement for your apple and lemon, with some grapes added. How about trying some vegetables?

*"The business of art is to reveal the relation between man
and his universe, at the living moment."*
 David Herbert Lawrence

Sculpting a Dolphin

The beloved, ever-smiling dolphin is a prime "simple" shape for us to work with. Dolphins share a mutual affection for humans and seem to represent a gentle but omnipresent freedom in the sea. Try to capture the grace of this beautiful creature in your sculpture.

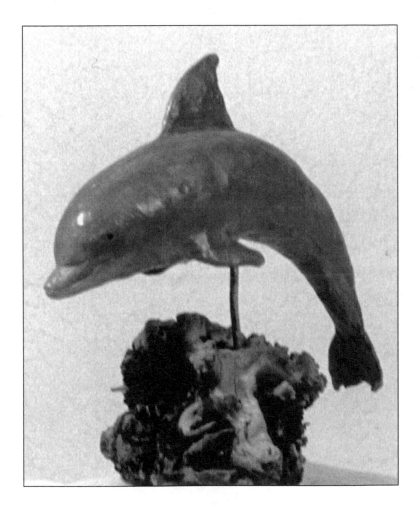

As we begin, you will be working while holding the clay in your hands, but toward the end finishing will be done with the sculpture on an armature to raise the finished dolphin sculpture gracefully above the table.

1. Base: An easy, attractive armature and base can be made by using a small block of wood about 3 inches square and 2 inches thick. Pound two long nails into it about 1/2 inch apart. You can also make the base out of your clay, insert the nails, then bake at 275° for 15 minutes. When it cools, you have your base.

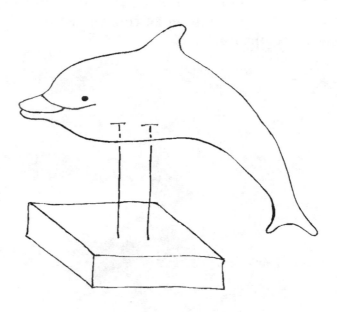

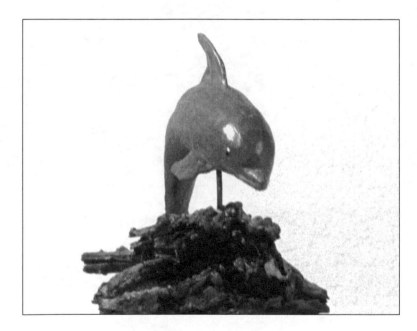

2. Work the sculpture off the base until step 6. Take up a piece of clay that will roll into a cylinder about 4-1/2 to 5 inches long and approximately 1-1/2 inches thick.

3. In a similar way to making the initial shape for the apple, ignoring the bottle nose for now, apply some pressure to develop the body of the dolphin from the full front to the sleek, thin back area at the tail. We will add the tail later. It will take a while to shape the curves around the head and abdomen. Take your time. Turn your sculpture often to get a pleasant fullness in this body area.

4. When you have
formed a nice body
shape, add a small,
slightly pointy
shape of clay to the
front of the head for
the nose, and make
the eye with the
point of your tool.
Score the mouth
into the head.

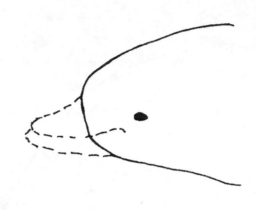

5. Make a shape
for the large dorsal
fin on top, and add
it now. Blend the
new clay until
smoothed into the
main body.

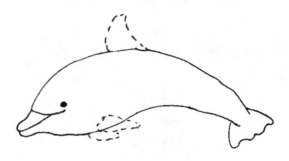

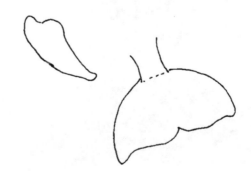

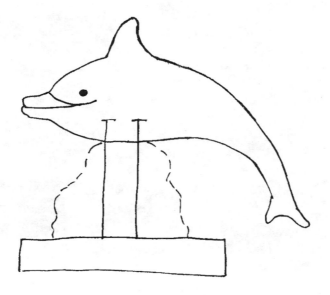

6. At this point, place the body on the base you've made. Form the shape of the smaller side fins and tail, and add them to your sculpture.

7. Add clay between the base and belly of the dolphin if your sculpture is slipping. Remove this support clay before baking. But leave the dolphin on the armature when you bake it.

8. The nails can be painted with black, gold, or silver acrylic paint, and the base itself can be painted black or given a metallic finish.

If using Sculpey: Bake at 275° for 20 to 25 minutes.

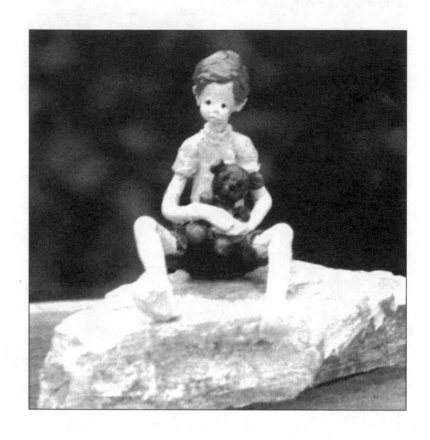

"Artist: One who doesn't see things as they are, but who he is."
　Anonymous

The lowly fish was long ago elevated from food source to a worthy subject of artists. The Japanese have attributed very noble characteristics to the koi, and Chinese have many beautiful legends in their culture as well. Goldfish, as we commonly refer to them, have turned up in period furniture, paintings of the masters, and Calder's mobiles. A goldfish, Cleo, was even a movie star—in Disney's Pinocchio. Now we'll do our own.

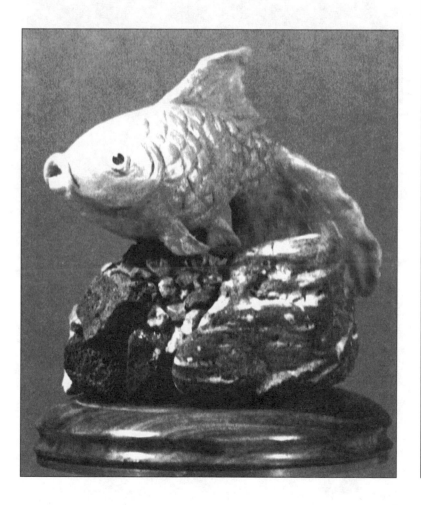

1. Base: You'll need the same type of base we made for the dolphin (page 24). Complete steps 1 through 5 before mounting your goldfish on the armature.

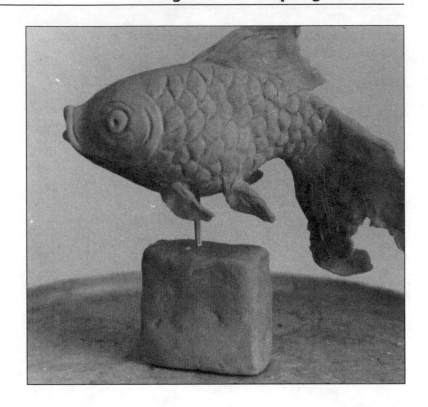

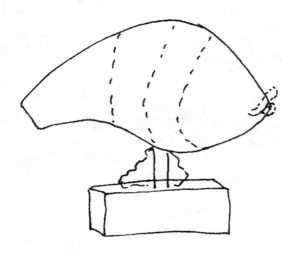

2. Make the body of the fish as shown in the drawing. The broken lines indicate the side contours. A good size to work is a body length of 4 inches, excluding the tail.

3. Turn your work often to keep all sides developing evenly. And take a minute to look down over your sculpture. You can easily check for symmetry this way.

4. Make the mouth of your fish by lifting upward with your finger at the front of the body. The lower jaw, pushed up slightly from underneath, should fit within the upper jaw. Notice the narrow lip above and below the mouth.

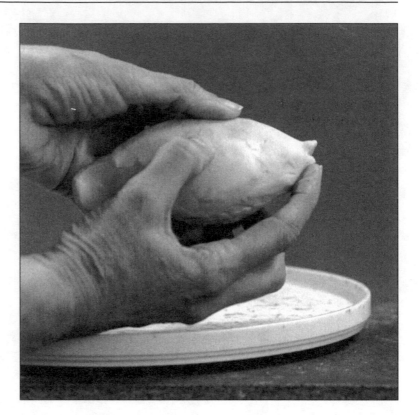

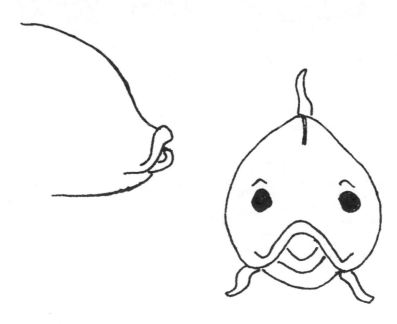

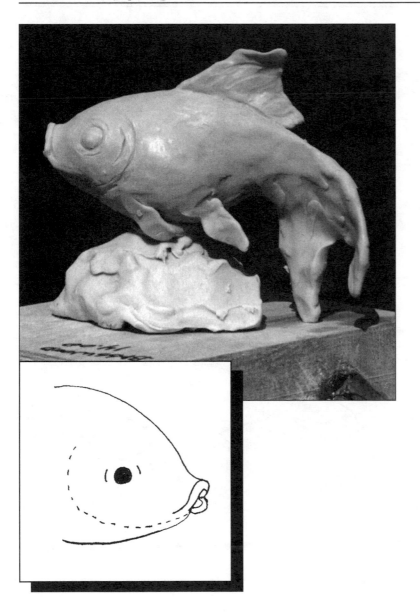

5. Score into the head with a tool to "draw" the placement of the eye, and press a small ball of clay into place there. Attach it by delicately pressing around the outer edge with a tool. Also score into the head area to mark the gills; start just above and behind the eye, and finish beneath the mouth.

6. It's time to mount your sculpture on the base you made earlier. If it should slip down, put clay between the belly and the base of the fish for added support, and remove it before baking.

7. The tail is made by forming the basic shape from a flattened piece of clay and then attaching it to the body. A fine wire can be embedded into the tail and body for support there. Work with the tail to give it a flowing appearance, as it would look swishing about in the water.

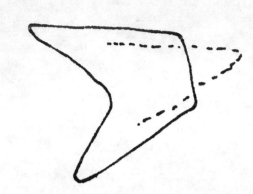

8. Add fins where needed.

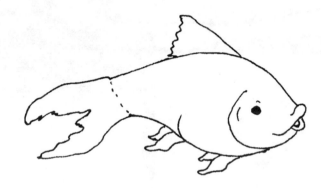

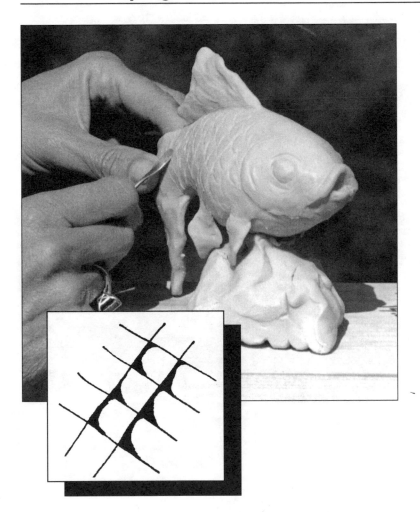

9. The detail for the scales is accomplished by crosshatched scoring over the body with lines about 3/8 inch apart. Then round one corner of each scale for dimension. A much simpler indication of the scales could also be very satisfactory.

If using Sculpey: Bake your sculpture at 275° for 20 to 25 minutes.

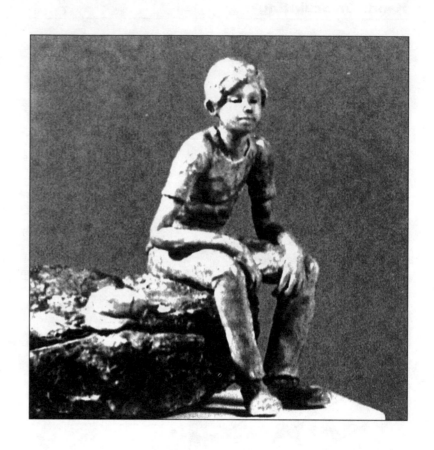

"Art strives for form, and hopes for beauty."
George Bellows

A Shoe by Any Other Name

With due respect to the major companies spending millions to promote an image of flair and taste, we are going to use the generic term and sculpt a "shoe." Here's an article of clothing that can reveal great insight into its owner. One's walk, work, and financial status can be learned from his or her tossed-off shoes.

For this exercise, you can work from my subject or go to your own closet floor! To begin together, let's do a right shoe about 4-1/2 to 5 inches in length.

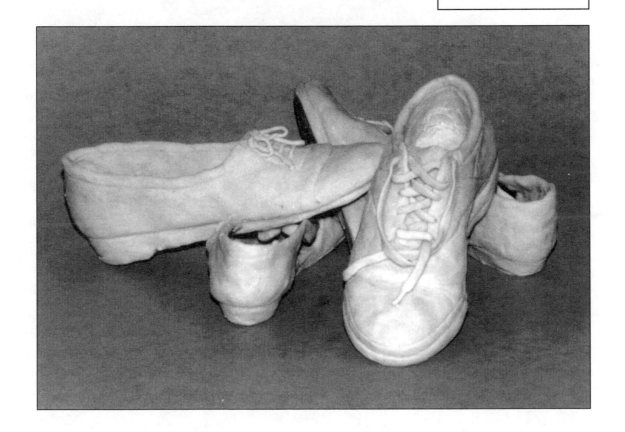

1. Begin by turning the shoe over and duplicating the shape of the sole in proportion to the size you'll be working. The shoe from now on will fit within this contour.

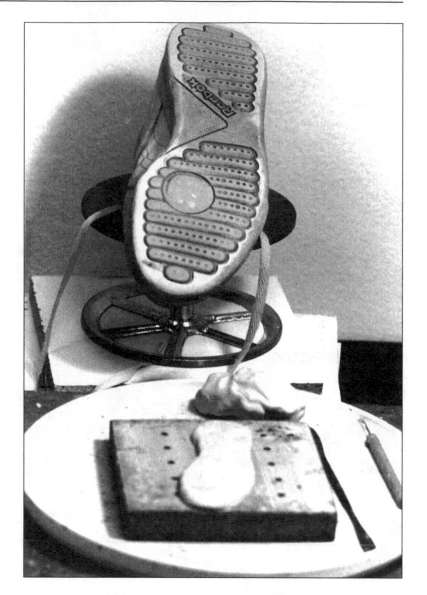

2. Turn the shoe upright again, and with a side facing you, begin to build the mass of the shoe from toe to heel, as you see it.

Try to envision an imaginary line of the shape of the shoe, and fill it in with clay as you would when coloring a picture. Sculpt it as a solid mass.

3. Turn often, working both sides the same, noticing whether the instep is higher than the back of the heel or vice versa. Next start shaping the indentation of the side of the instep.

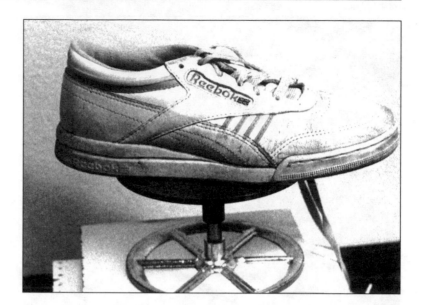

The subtle indentation at the instep area, from the back of the toe into the heel area, can be difficult. For now, ignore detail in the lacing area.

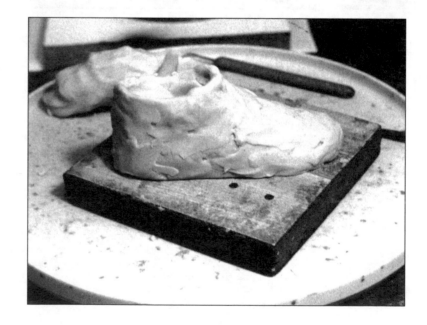

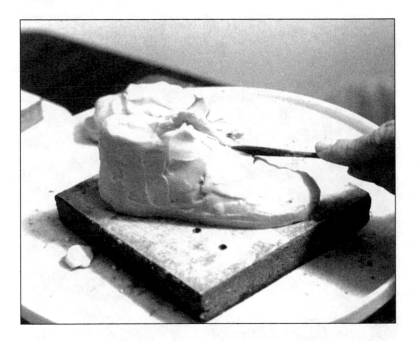

4. For a tie shoe, create the tongue and overlapping areas for the laces by making cuts down the front upper instep and then separating and lifting each side.

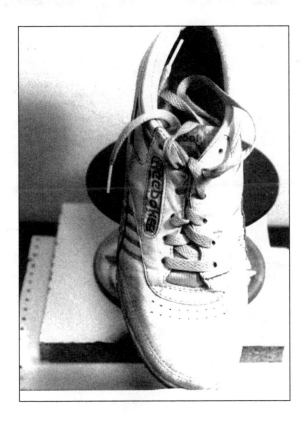

5. Place the shoe with the toe toward you. Check the proportions this way, then from the back. Keep turning to develop the whole shoe. Notice how it narrows as it builds up around the foot. Notice the contour the upper shoe takes coming up from the sole. There's an indentation and then a rounding over the foot.

6. Now it's time to add surface detail. Score into the surface the stitching pattern or any other design your shoe may need.

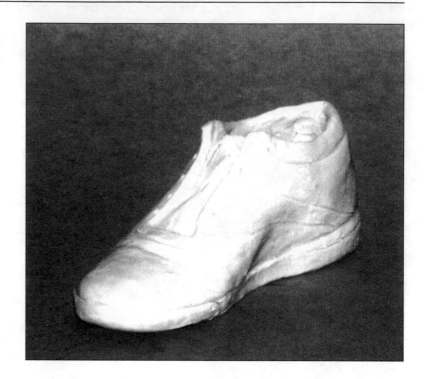

7. You needn't sculpt out the entire interior of the shoe, but carving out an inch or so will give your sculpture good depth.

8. Once you have the overall shape of the shoe, stand back and look at it. Does it look stiff? A shoe curves up at the toe and usually wrinkles where it bends. Turn up the clay by gently bending it in your hands, and give it a push or a little squeeze here or there for the broken-in look. There is a slight turn-up to the heel too, which can be carved from underneath.

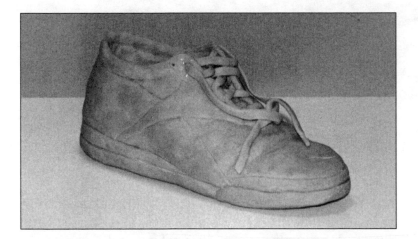

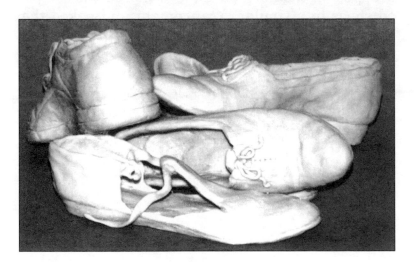

9. I didn't actually lace my clay shoe! But for a realistic look, after the holes were made, I added sections of the lace, pressing each section in place into the hole. The laces themselves were made by rolling small coils of the clay, then flattening them.

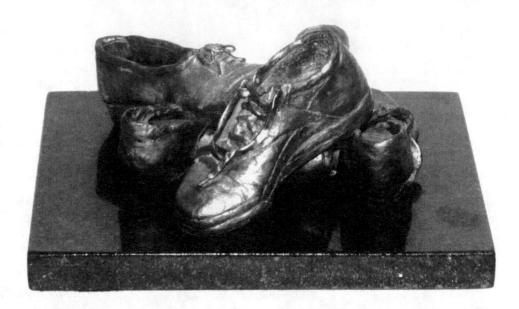

If using Sculpey: Bake at 275° for 20 to 25 minutes.

After finishing my sneaker, I sculpted two other pairs of shoes from my closet. All the shoes were dropped on the floor, as usual. I placed the sculpted shoes in a similar arrangement and baked the whole thing. Finally, I painted acrylic metallic paints over the sculpture for a bronze effect.

"Art is the desire of man to express himself, to record the reactions of his personality to the world he lives in."
 Amy Lowell

The "Beetle" was originally the twinkle in the eye of Ferdinand Porsche. World War II stalled its design and development, but German production resumed in 1948, on sunny days only, in a bombed-out factory with a partial roof. The Beetle's subsequent success is history—and more. This little German car is an American legend.

I know during this project you'll be staring down every VW you can find! I still am.

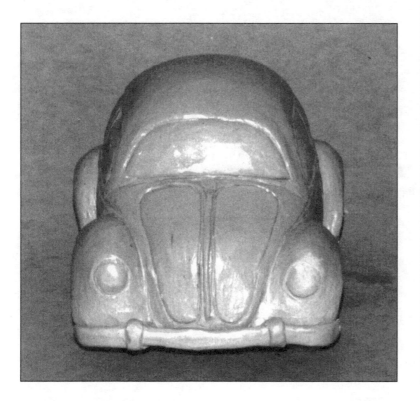

The Beloved Volkswagen

1. Inserting core material: Since this sculpture is a large, solid mass, you can save clay and bake more evenly by making a core of aluminum foil, paper towel, wood, or something similar to wrap the clay around.

2. Start building around the core. Again, looking at the shape of the car, think of an imaginary line or contour, and fill it in with clay.

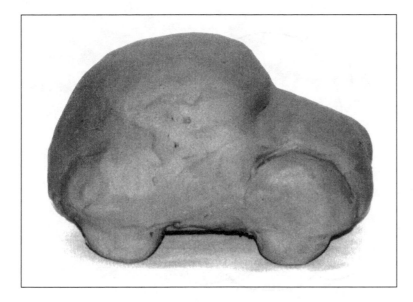

3. Carve out the area shown. Rough in the fenders on the side. Concentrate on the shape of the roof as it slopes back and down and also on the way the front hood meets the windshield.

4. Look at the Beetle's shape from front and back, then from one side and the other. It is the same width front to back. The broken lines in the drawing represent the running board, to be added later.

5. Wheels: After you get a nice allover body to your car, turn it over with the bottom facing up. In each corner, attach a half circle of clay about 5/16 inch wide for a wheel. The wheel should meet the frame of the car at the center of the wheel heightwise. Remember to securely blend all new clay into the body.

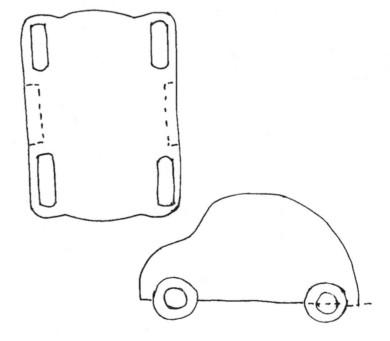

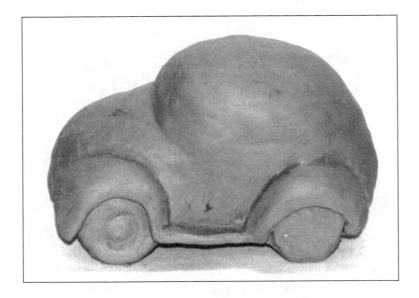

6. When the wheels are in place, turn the vehicle right side up, and carve out the rest of each wheel to give the appearance that it is separate from the frame. Score and carve into each one to make the hubcap and the indentation around it. Some patience is required, but it's fun, isn't it?

7. It's now time to build finished fenders over the tires. Score the doors in place to be sure you maintain the correct proportions. The front fender has a squared-off front where the headlight is held. There's a narrow running board between the front and rear fenders on each side.

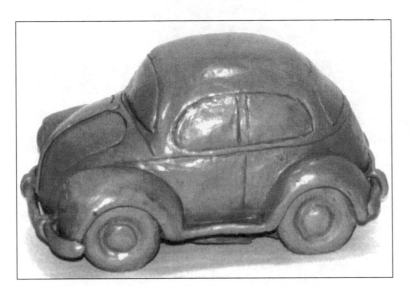

8. The front windshield squares off from the hood and goes up to meet the roof in a steep, almost 90° angle.

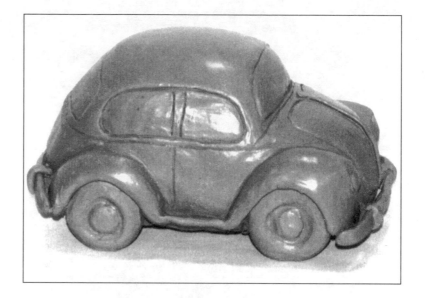

9. Give solid, rounded curves to your car. Then make deep indentations to mark the separation between the body and the fender area, front and rear. Score the headlights into the front fender, then round them off.

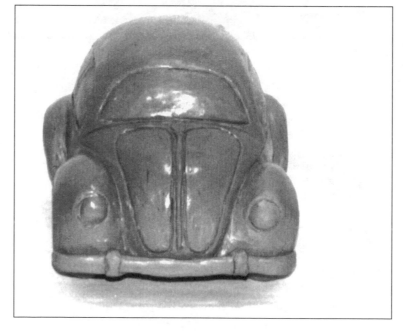

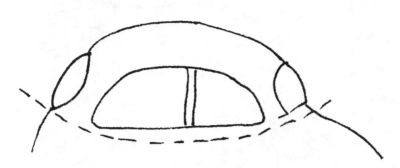

10. It's now time to do all the surface detail, which entails making the windows and sculpting the hood detail, doors, and so on. After you draw the windows, try to curve the glass area where it meets the window frame for better definition.

11. **Bumpers:**
The bumpers are last. Roll two long pieces of clay, then flatten them. These will be the bumpers. Measure them against the car to see that they are wide enough to go from fender to fender. Place two little blocks of clay (as shown in the diagram) where the bumper will attach to the body. Before attaching, wrap two small flat pieces around the bumper as illustrated, to align with the two blocks that you just added to your car. This will give you even more clay for attaching. Another good idea is to embed fine wire into this attaching site for strength. Give the fender a proper curve, and there you have it.

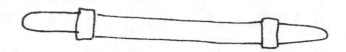

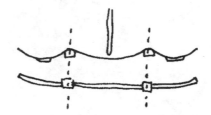

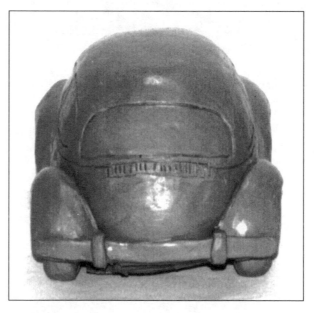

If using Sculpey: Bake at 275° for 25 to 30 minutes.

"A work of art is a part of nature as seen thru a temperament."
André Gide

I love giraffes, so I was eager to use them for one of the projects in this book. They are docile, peace-loving, unique animals. No one will ask you what you're making!

I think you'll enjoy this project, but for all the work going into it, it's worth it to use Sculpey so that the effort can be saved. I wish I had!

Sculpting a Giraffe

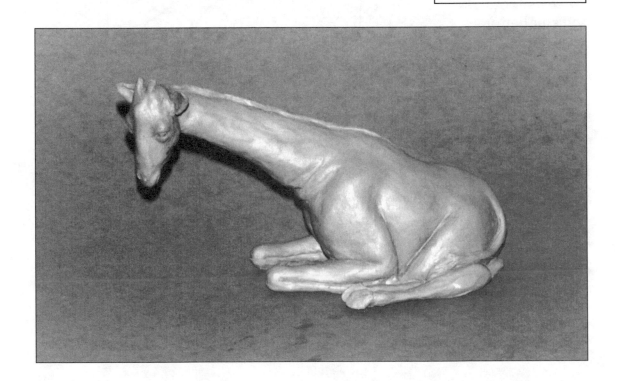

Drawing an animal can be simplified by start-
ing with a cartoon drawing. This same concept
can be applied to sculpting an animal. A simpli-
fied shape can be used to get to the more detailed
sculpture later.

1. Start by
putting two circles
together, as you see
here. The larger cir-
cle, which is almost
twice as large as
the smaller one,
represents the
shoulders and front
part of the body.
The smaller circle
represents the hips
in the rear.

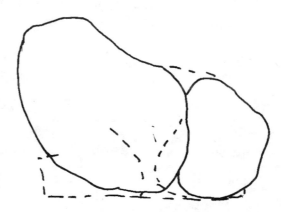

2. With your fingers and a tool, begin blending the two circles into a single body mass. Work to achieve the angles of the body. Other pictures of giraffes from other sources will give you additional information to work from. Research like this is very helpful in more difficult projects.

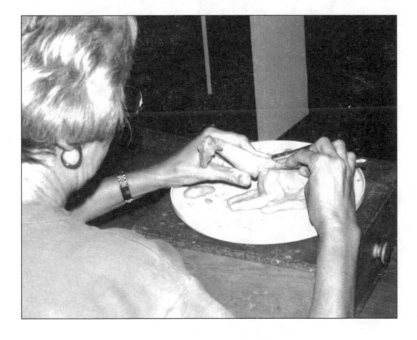

I'll let you look over my shoulder as I sculpt my giraffe!

3. Add two cylin-
drical pieces to the
front of the body for
the front legs,
which are folded
under. Blend them
into the body.

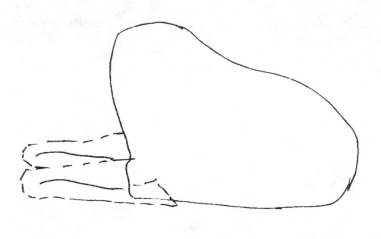

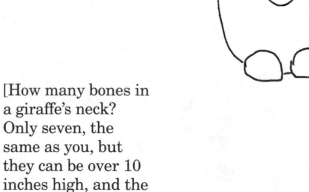

[How many bones in
a giraffe's neck?
Only seven, the
same as you, but
they can be over 10
inches high, and the
giraffe's neck can be
6-1/2 feet long.]

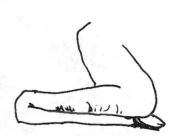

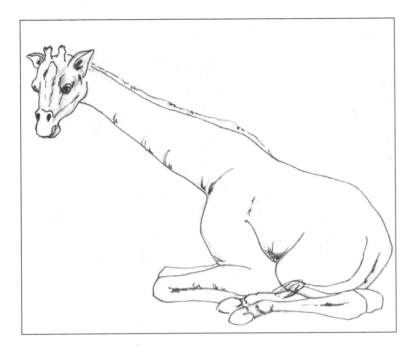

4. With the body roughed in and the front legs in place, it's time to add the neck to the body. Use a toothpick to hold the neck securely in place. Blend the two pieces together.

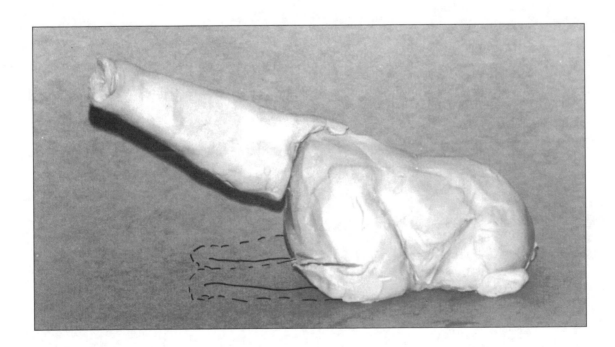

5. **Head:** When complete, the head should be approximately half the length of the neck. Make a clay oval for your giraffe's head in this proportion. Use half a toothpick as a handle while you do the detail on the head.

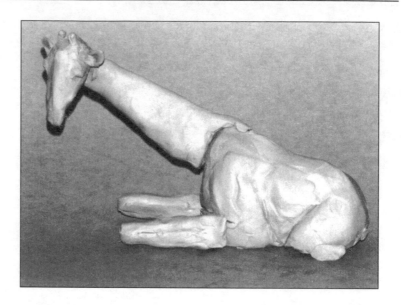

6. Construct the basic shape as shown here. Notice that the snout has a sharp peak from the nostrils to the center horn on the forehead. Add the bulge on each side that encloses the eye, then the rest of the detail. The ears are just behind the eyes.

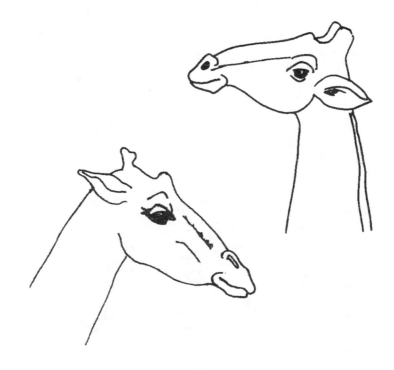

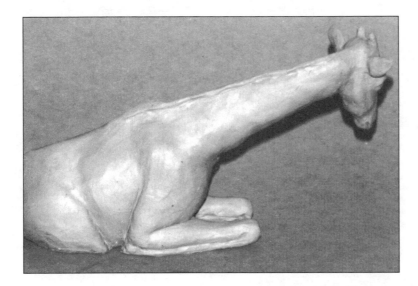

7. When the head is finished, fasten it to the neck by pushing in the toothpick until both sections are flush. Blend the clay to hide the seam, adding some new clay over the area if necessary.

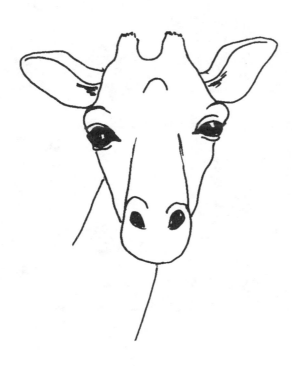

8. **Rear legs:** The small piece of clay in the photographs represents the leg underneath the animal. The rest of the leg is under the body, then off to the side with the other one. Lay two cylindrical pieces at a 45° angle coming out from under the giraffe. The legs narrow at the front. Also add the tail.

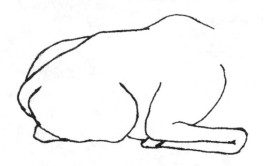

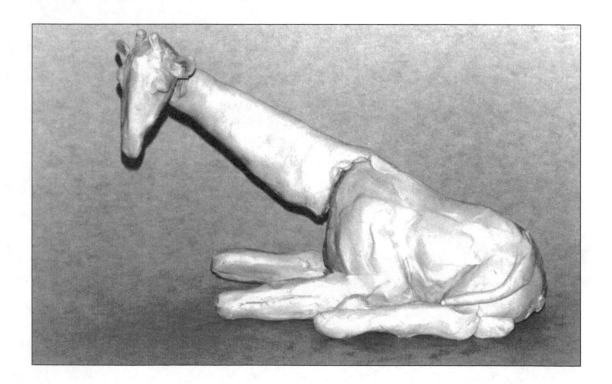

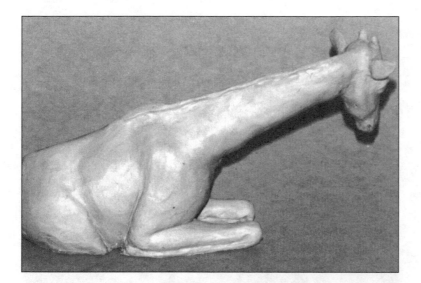

9. From the back you can see that the animal is sitting on the right leg and leaning back on the right hip. This posture puts the backbone slightly off center.

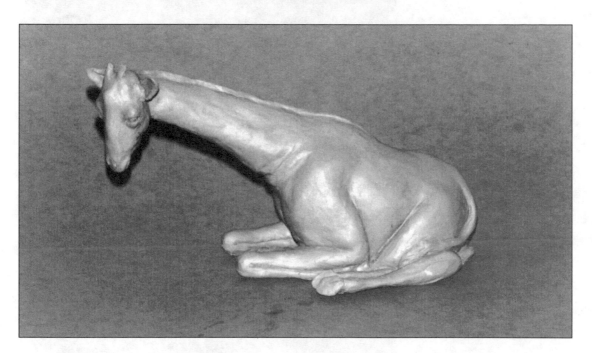

If using Sculpey: Bake at 275° for 20 to 25 minutes.

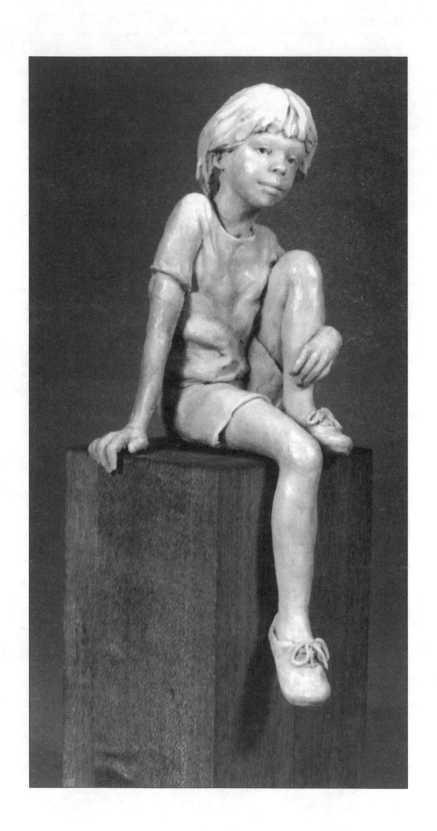

This is my daughter's English riding saddle. There is great beauty in its craftsmanship and weathered leather. By itself, but especially with the boots, it makes a very interesting still life sculpture.

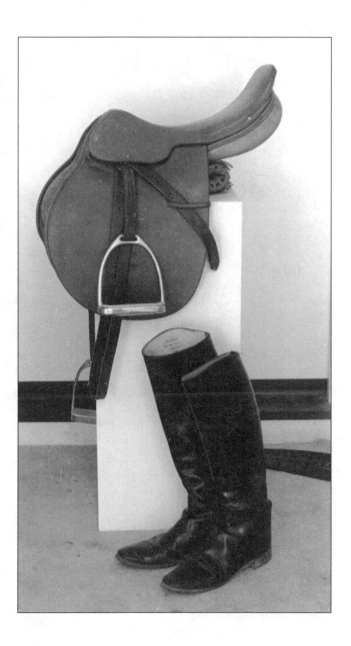

Sculpting a Saddle and Boots Still Life

1. **Stand:** To support a saddle 3-1/2 inches by 3-1/2 inches, find a block of wood 3/4 inch thick and at least 3 inches high. You can make the block from clay, but be sure to bake it before starting the saddle so you can get them apart as you're working.

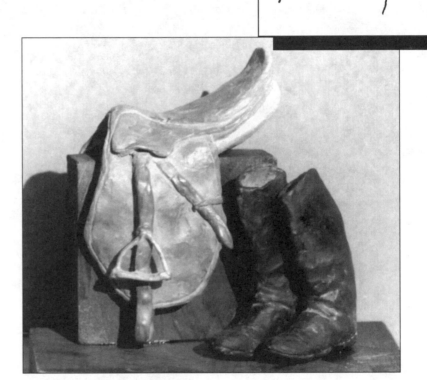

2. Start the saddle itself by building up clay between the front rise and rear of the seat (pommel and cantle). Work with small, solid pieces, building to fill in an imaginary contour line in the shape of the saddle. When you can begin to see the shape forming, begin smoothing the small pieces together. Finish detail will come later. Note that clay is used to steady each side of the base.

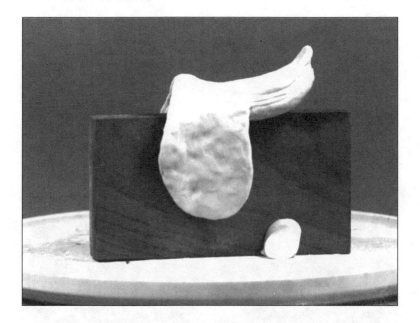

3. Add side flaps made from flattened clay. Attach them under the saddle seat. The side flaps fit from the front to a spot about halfway back. Just rough things in now. Turn your work often to get both sides the same.

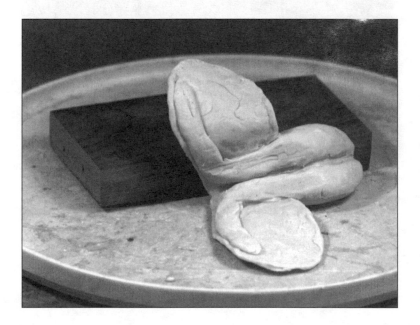

4. At this point, lift the saddle off the base and turn it over, underside up. It's time to add the thick cushion of leather under the seat, which begins at the front and curves up under the back. This cushioning also lies under the front of the side flaps, as illustrated.

5. When you've added the side flaps and the cushioning, place the saddle back on the stand. Before moving on to the saddle detail, place a piece of clay up against each side of the stand to steady it.

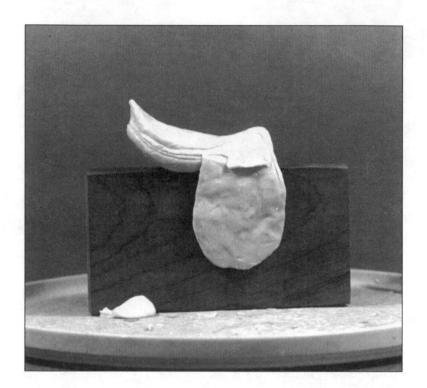

6. Saddle detail: The dip in the seat shouldn't be too deep. The forward line from the pommel to the side flap is important. Score a line around the top of the saddle for the basic seat outline. Build up this area to separate it from the underlying leather. There's another ridge of leather between the seat and the cushion underneath. With your tool you can separate each of these layers or blend them into just one contour, simplifying some detail.

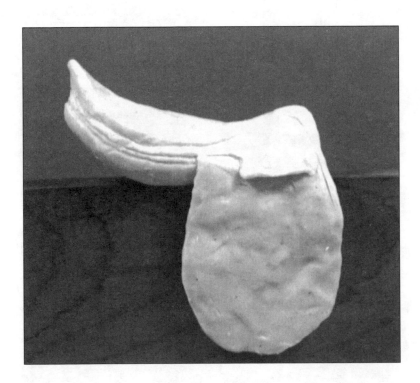

7. Take some time now to rework your detail, smoothing the seat and the side flaps. If you choose, this is the time to score the stitching around the edge of the side flaps.

8. There's a small flap at the top of each side flap that covers the top of the stirrup strap. Add a small rectangle to this area on each side of the saddle, and blend it into the saddle around three sides, lifting the bottom edge for addition of the stirrup strap.

9. **Stirrups:** Be sure the saddle stand is supported. To make the stirrup straps, roll narrow coils and flatten them to about 3/8 inch. They need to be long enough to fold over and fit as illustrated. Fasten each folded strap under a small flap. Then do the strap that angles to the back of the flap. Do the same on the other side.

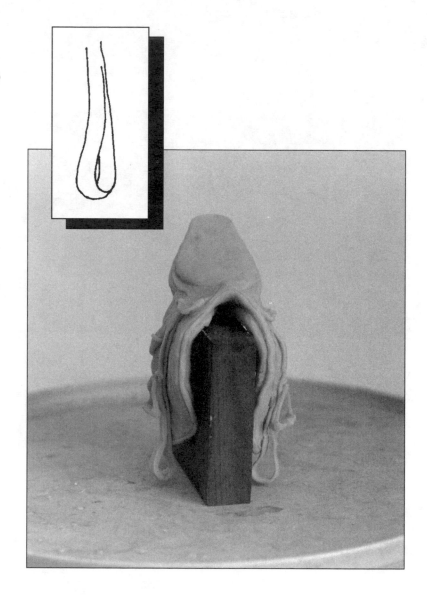

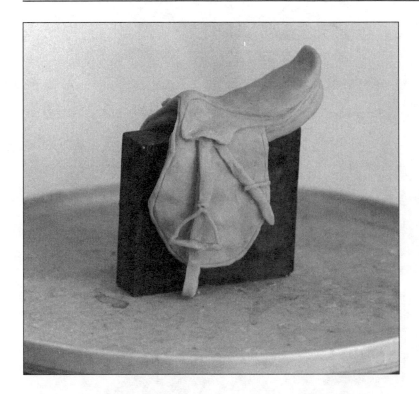

10. The delicate stirrups are made separately and attached after baking. First make the flat section that holds the foot. Then attach a very small coil to each end of the flat piece. Lift the coil into shape with your tool and support it with a small wedge of clay. You don't want to press the pieces together, but slight touching against the wedge piece is OK.

11. When the stirrups have been baked and cooled, gently snap out the support pieces. Glue the stirrups in place with a dab of a strong, fast-drying glue. You may also glue or tack the saddle stand to a base before attaching the straps and stirrups, to keep from tipping the stand over, if possible.

12. Because of the fragility of these straps and stirrups, you may want to add a couple of coats of spray epoxy or clear nail polish. It works well to add strength and rigidity. Finally, finish with acrylic paints or stains. If you have any breakage, repair it and bake again.

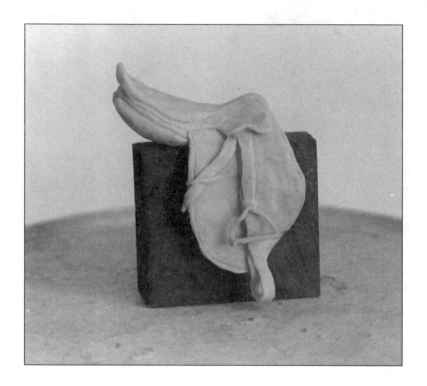

If using Sculpey: Bake at 275° for 20 minutes.

Now the boots. Try to make them look well worn, and be sure to make them large enough.

Boots

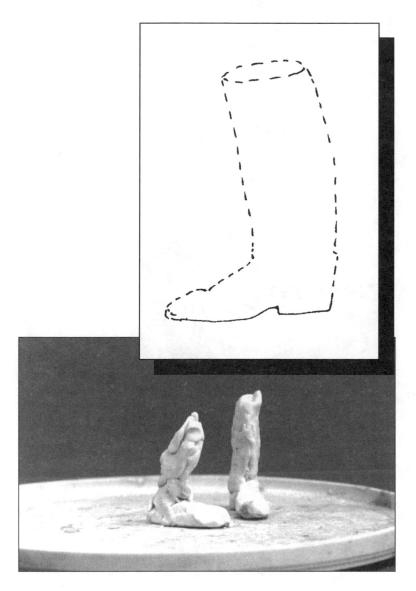

1. First make the sole of each boot, one right, one left. Next build the boot, visualizing the imaginary lines of its contour. Use small, solid pieces of clay. Note how the boot tends to lean forward toward the top. Build the tops up to a thin, vertical lip, higher on the outside edge. When you have the basic boot constructed, score around the base of each foot for the sole separation.

2. Lift and separate the upper leather from the sole. Lift the toe, slightly bending up from under the sole, and make creases at the ankle and on up the boot for a broken-in look. Carve into the tops a little for an illusion of openness. Finish your boots to match your saddle—painted, stained, or waxed.

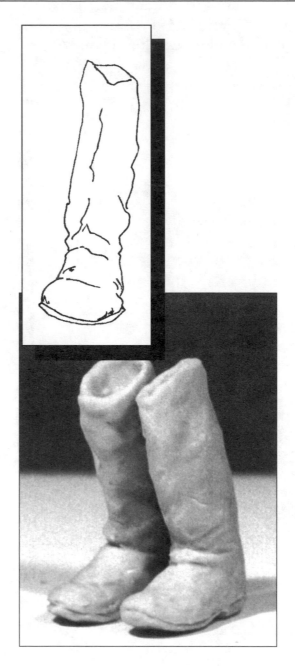

If using Sculpey: Bake at 275° for 20 minutes.

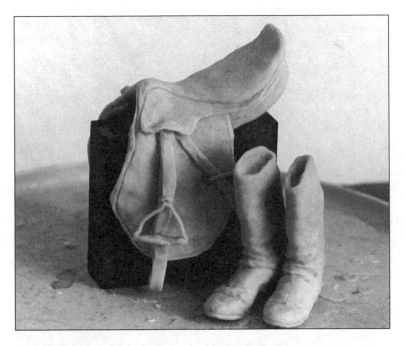

I hope you're happy with your saddle and boots. You could add a riding helmet or crop for even more interest.

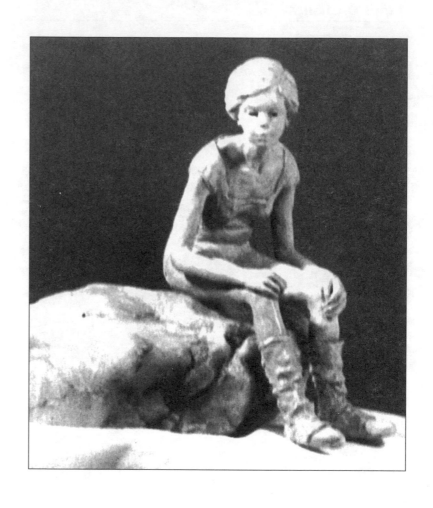

5

The Human Figure: Hands-On Sculpting

"A work of art has an author, and yet, when it is perfect, it has something anonymous about it."
 Simone Weil

Introduction

As a preamble to sculpting people, I will refer you to any one of the many anatomy books written for artists. They are clearly illustrated and will fascinate you with facts about the human skeleton.

Proportions

Practice doing figures of proper proportions from the measurements given here. Use photos or yourself as a model. Remember that there should be no drooping or bends along the bone, only at joints.

There are no square corners on your body. Even the most protruding bones are rounded.

The head is the main unit of measurement for sculpting the body. A head too large or too small will immediately distort your sculpture.

As with any project, practice makes perfect.

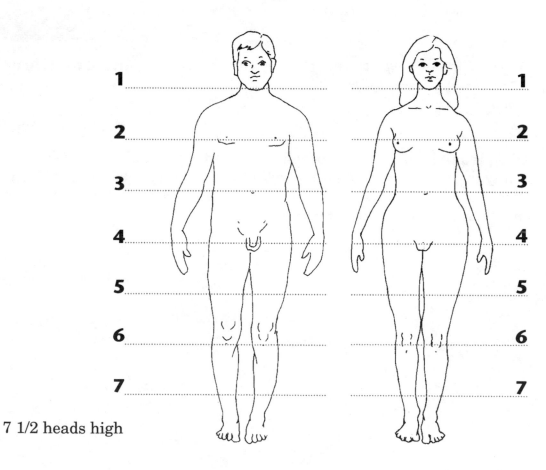

7 1/2 heads high

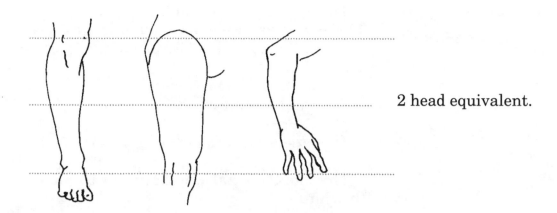

2 head equivalent.

Here are some basic measurements to get you started:

body height = 7-1/2 heads
1 head = shoulder to elbow = elbow to wrist
2 heads = hip to knee = knee to base of heel
4. heads = top of skull to hip

1 head equivalent.

The eye is the measurement within the face. The eyes are one eye apart and are halfway between the top and the bottom of the face.

width of head = 5 eyes
width of nose at nostrils = 1 eye

The nose is halfway between the eyes and chin.

The mouth is halfway between the nose and the chin.

The ears are halfway back on the side of the head, falling vertically between the eyebrows and the base of the nose.

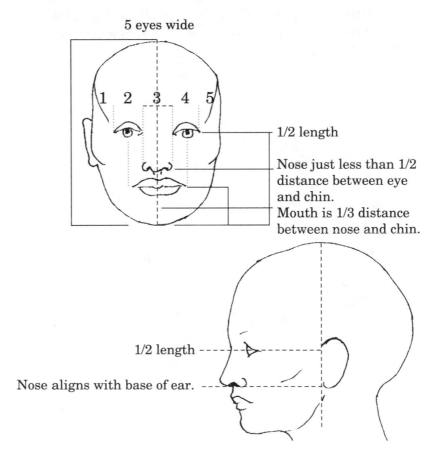

5 eyes wide

1 2 3 4 5

1/2 length

Nose just less than 1/2 distance between eye and chin.

Mouth is 1/3 distance between nose and chin.

1/2 length - - -

Nose aligns with base of ear. - - -

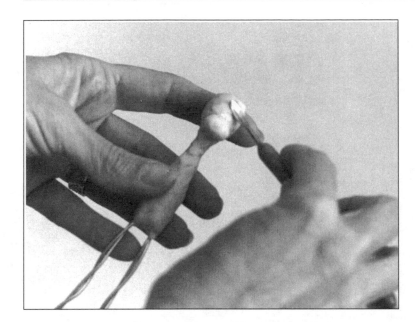

3. Wrap a section of clay over the body area of the armature, and put a small ball of clay over the head loop. Complete step 4 before placing the armature in the base.

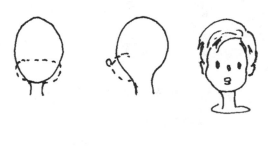

4. **Head:** The head should be an oval shape. Halfway from the top, score a horizontal line. This will be the placement for the eyes. This is also the upper line of the cheeks. Round each side, and lift at the bottom of the head for the chin. Remove a little clay from the cheeks upward for the forehead. When you've formed the cheeks, add a small

button nose. Blend
it against the face
to tack it in place.
Add another small
ball for the mouth
and score the center
horizontally to sep-
arate the lips.

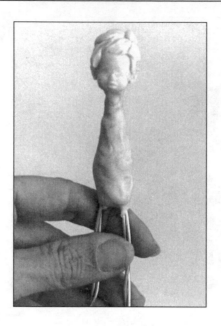

5. The eyes can
be made with the
sharp end of your
tool or be painted
on later. The ears
are located vertical-
ly between the eye-
brows and the
bottom of the nose,
halfway back on the
side of the head. I
make an ear by
flattening a small
ball in place, then
cutting away the
front third of it.
Secure this edge
and lift the back of
the ear away from
the head a little.

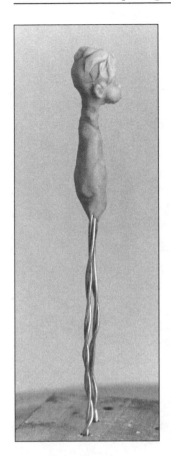

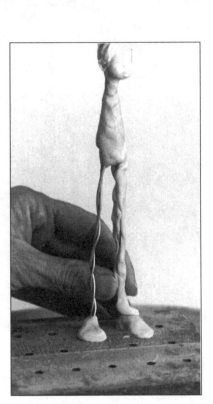

6. Place the armature in the base. Place a little clay in front of the foot for support. Cover the rest of the armature with clay. A thin rolled coil can easily be wrapped around the leg wire.

7. **Clothes:**
Remember to blend
in new pieces of
clay as you join
them.

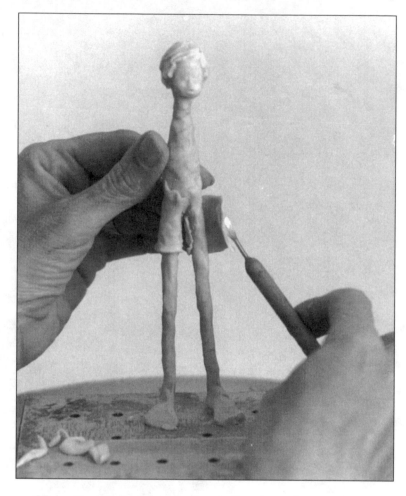

Shorts: Make two rectangles just large enough
to wrap around the top of each leg. Fasten at the
inside of each leg or in back.

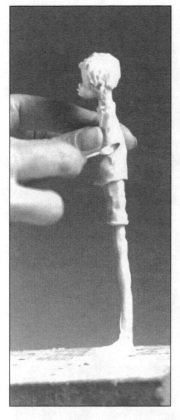 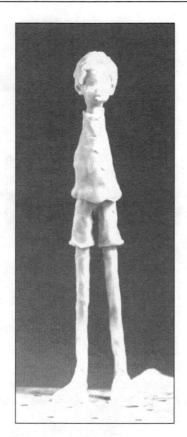

T-shirt: The t-shirt and dress are made the same with an adjustment for length. For the t-shirt, flatten two triangular pieces of clay to fit from neck to waist. Attach under the arm and blend into the shoulder.

Dress: The triangular piece should extend from neck to thigh. Join at the shoulders and under the arms; then use a finger for support as you join the pieces where they don't rest against the body.

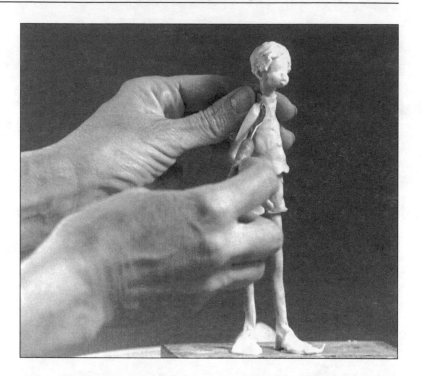

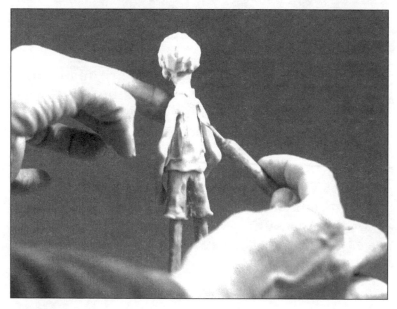

Arms: Roll two coils that measure from the shoulder to the upper thigh, and attach at the shoulders.

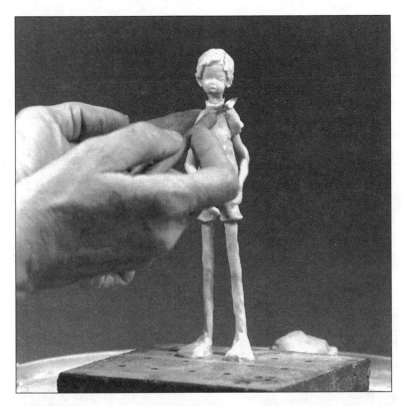

Sleeve: Make a small rectangle just large enough to wrap around the arm. Attach it under the arm and into the shoulder. Repeat for the other side.

Sock: A tiny coil can be wrapped around each leg. Flatten the lower edge against the leg for the appearance of a sock.

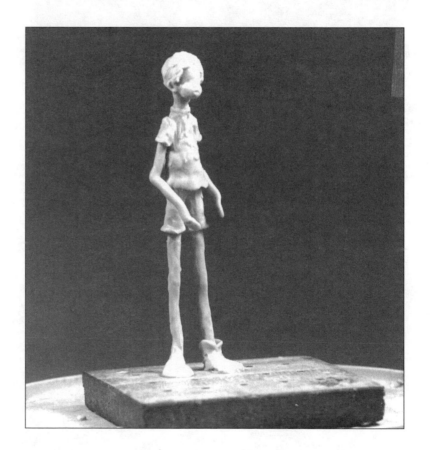

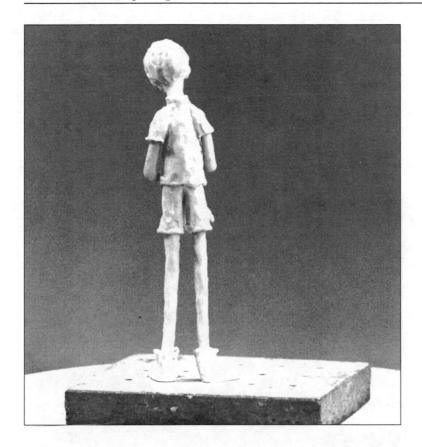

Foot: (Also refer to photo on previous page) Shape each foot for right and left. Wrap a small piece of clay around each ankle for a shoe top.

Before baking you can add any sort of personal embellishments. Place a teddy bear, doll, or fishpole in your sculpture's hands. You can add a hat, backpack, or anything else you think of.

Leave your sculpture intact and on the base to bake it. Set the formica, wood, or clay base on a cookie sheet, and place it in the oven. I've baked my formica base a hundred times or more!

If you're using Sculpey: Bake at 275° for 20 minutes.

When the figure has cooled, you can paint it with acrylics or antique it and brush on an acrylic semigloss for a little sheen. To paint your figure, leave it in the base to prevent tipping.

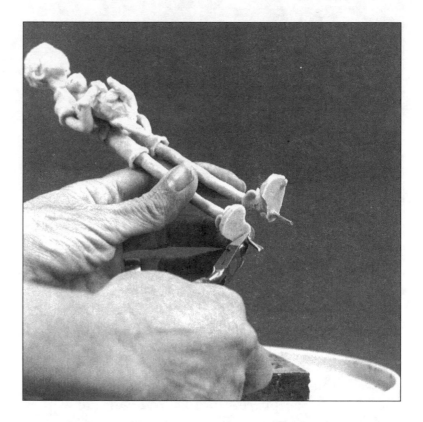

You can make it a freestanding figure by clipping the protruding leg wires flush with the bottom of the feet. Glue the figure to a small square of clear plastic or baked clay if it appears top-heavy.

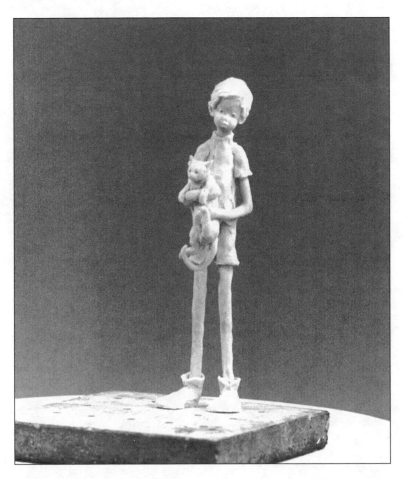

*Here we have a finished person. A personable chap
and his adoring, slightly nervous cat!*

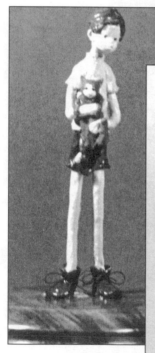
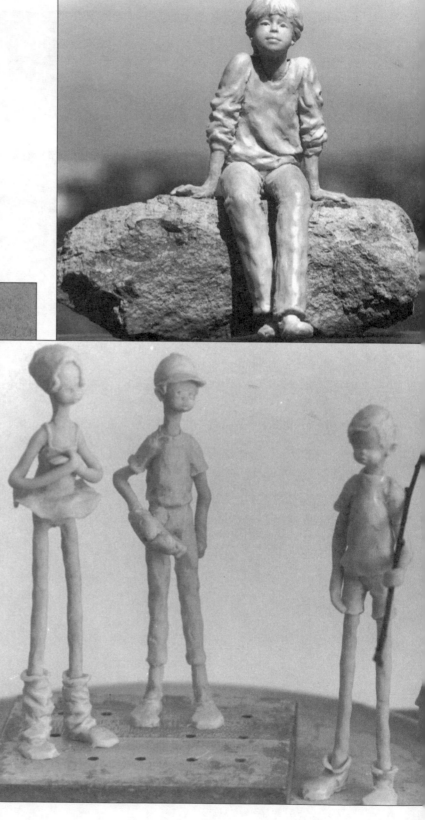

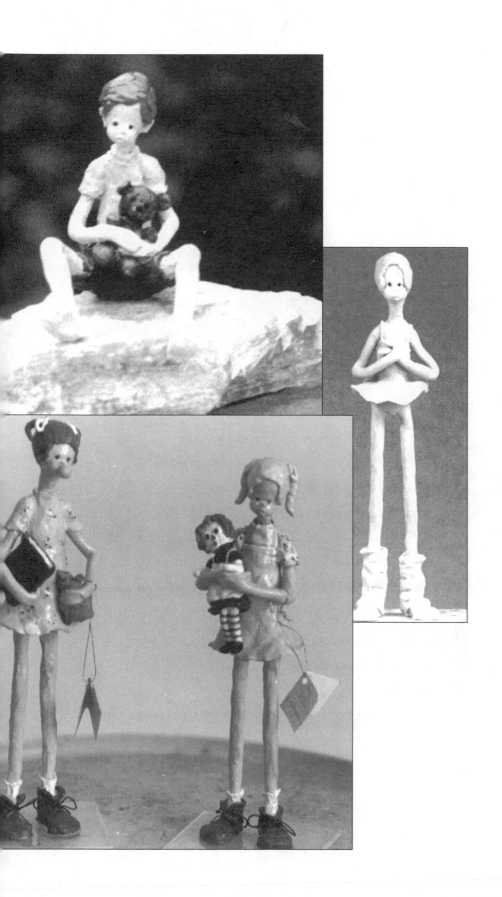

"I don't believe any real artist cares whether what he does is art or not. Who, after all, knows what is art? I think real artists are too busy with just being and growing and acting (on canvas or however) like themselves, to worry about the end. This end is what it will be. The object is intense living fulfillment, the greatest happiness in creation."

Robert Henri

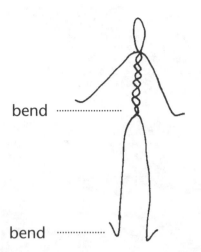

bend ·········

bend ·········

2. Cut a 10 inch length of wire for the arms. Wrap tightly, as illustrated, around the neck of the armature. If the wire is too long, it can easily be trimmed when you proportion your figure. Don't trim it until the arms are finished.

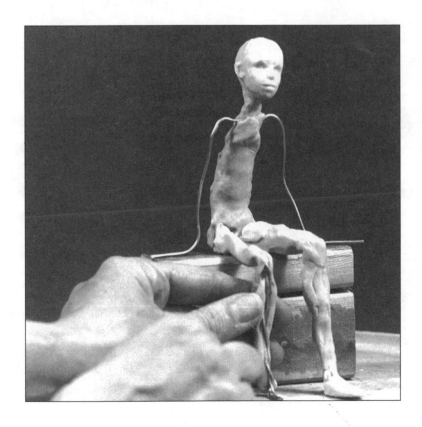

3. Holding your figure in front of you, wrap the torso with a ball of clay, and put a smaller ball over the head loop. Make an oval face and a full cranial area in back. Score shallow lines to mark the midpoints of the face, vertically and horizontally. (Refer to page 80 for the correct proportions of the features.)

4. Round the cheeks, gradually narrowing to the chin. The face is flat across the eyes but is rounded from there down. The mouth is built on that same curve.

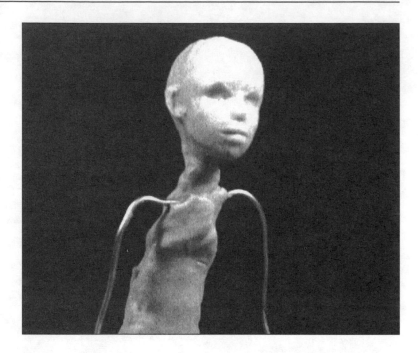

5. For the eye, place a small ball of clay in the socket, another over the eye socket, and press in place at each corner and around the top of the lid. Open the lid where the pupil is located.

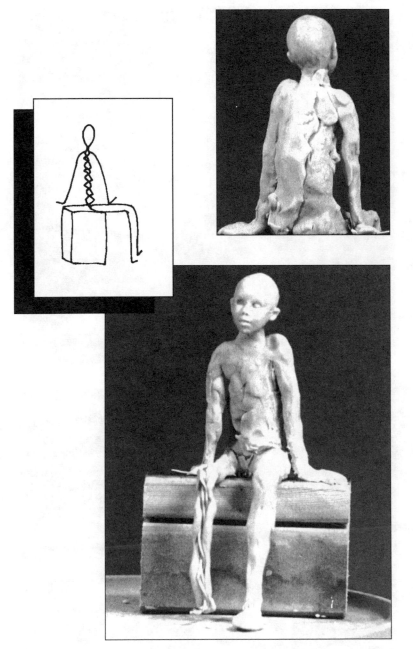

6. **Working the figure:** Bend the figure at midpoint and put it in place on the wood or rock. Begin building up clay on the torso. Roll coils of clay and wrap them around the arm and leg wires. Bend half an inch of wire at the ends of the arm wires for the hands.

I built up the shoulders without changing the original arch of the wire. Find a good picture if you need a resource for sculpting arms and legs. Also, check the proportions on page 78. Make a mitten-style hand that you can later cut into fingers.

7. Add pieces of clay over the top of the head for hair, and work it as it grows.

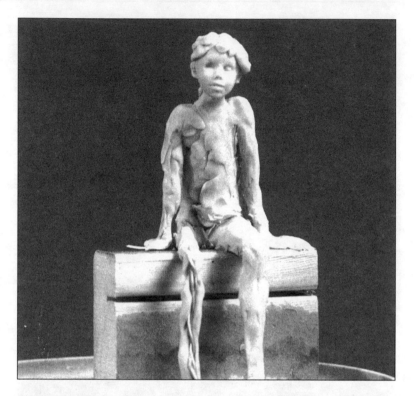

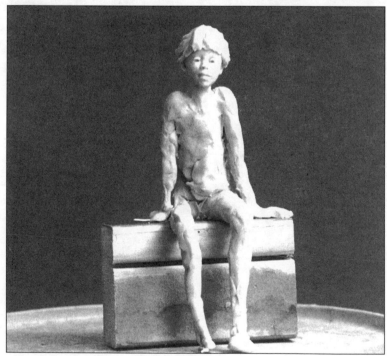

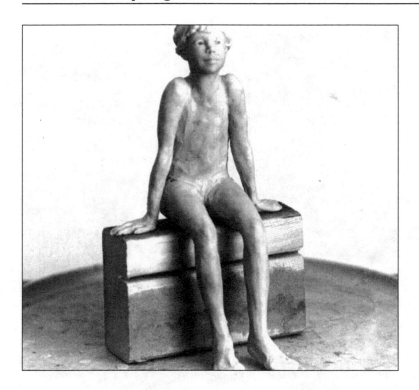

8. It is important to have the body well executed before adding the clothes. Dress by laying pieces of clay over the body. In areas where clothes fit tightly, lay small coils of clay in place and blend the edges into the body.

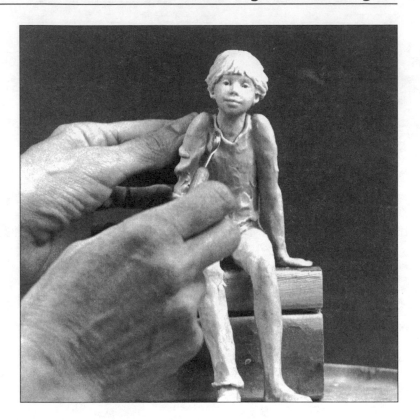

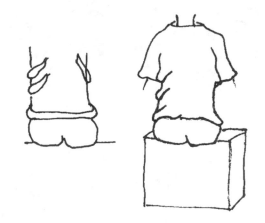

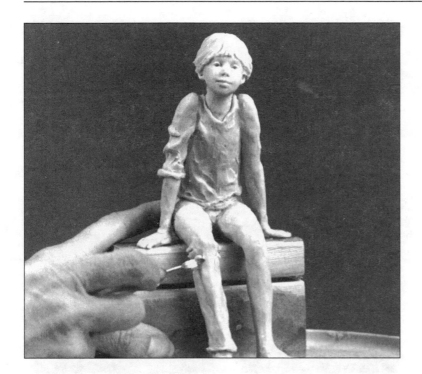

Study the folds in your clothes. Notice what jeans do when you're seated in them at the knees and ankles.

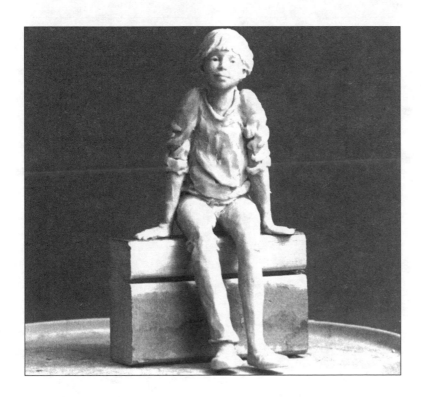

9. Place the entire figure, including the wood or rock, on a cookie sheet to bake.

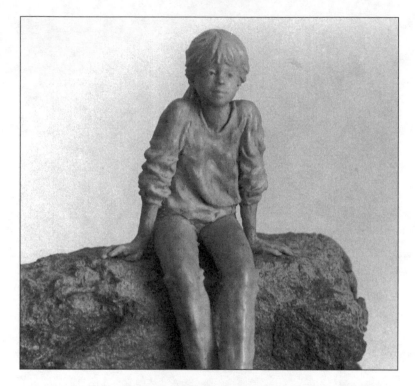

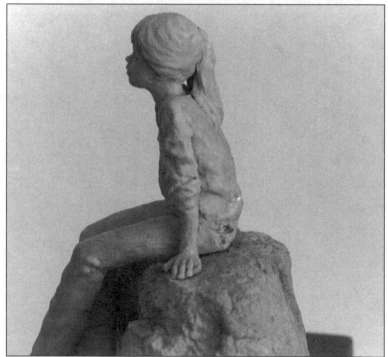

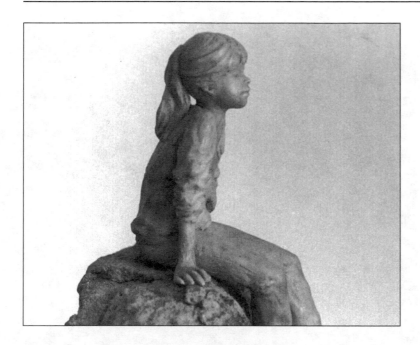

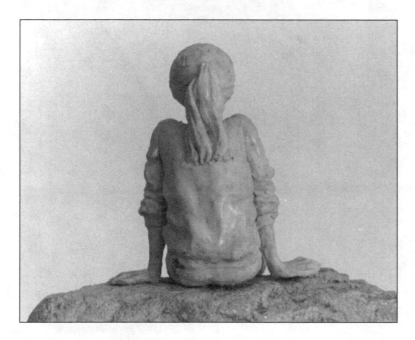

If you're using Sculpey: Bake at 275° for 20 to 25 minutes.

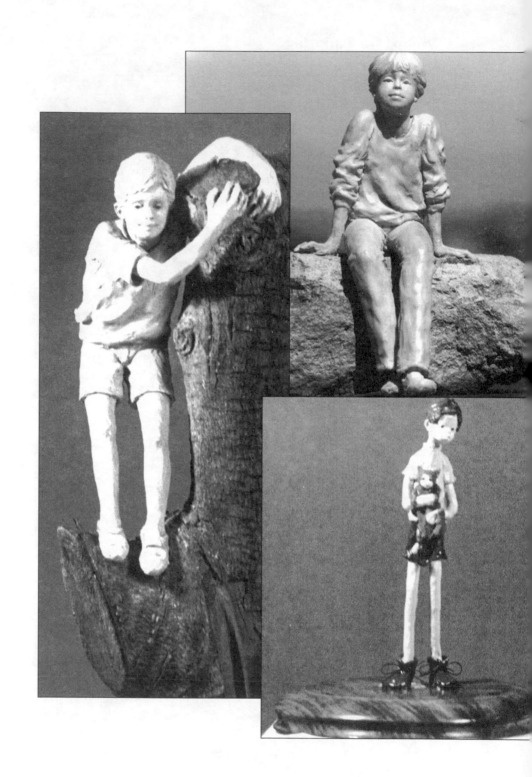

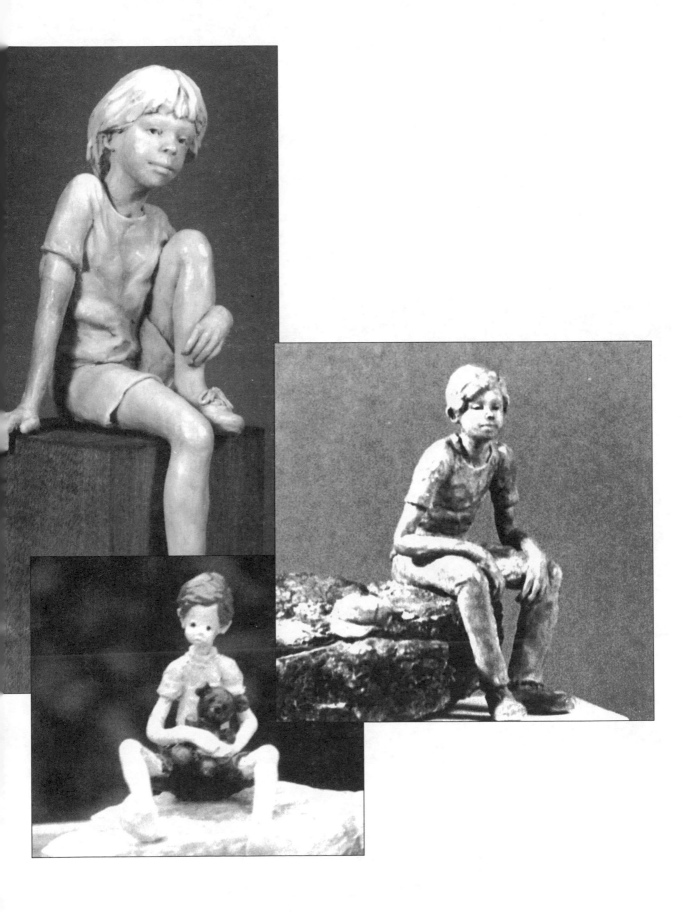

Suppliers

Sculpture House, 30 East 30th Street, New York, N.Y. 10016. Mail order supplier of all clays, stands, tools and wires.

H.R. Meininger, 499 Broadway, Denver, CO 80203. Complete lines of all supplies and art books in-house.

Aaron Brothers Art Stores, 70 stores in California, Arizona, and Nevada. Clays, tools, wire, acrylic paints and finishes.

Michaels Art Supplies. Stores in 19 states. Clay, tools and acrylic paints.

H. G. Daniels. Stores in Los Angeles, Santa Ana and San Diego. Sculpture stands, clay, tools and books.

For animal sculpture reference:

Zoo Books, 3590 Kettner, San Diego, CA 92101. Reasonably priced. 57 assorted animal books are available in book stores, zoos and museum gift shops nationwide and by subscription. Color photos and brief anatomy.

In other areas, check your Yellow Pages for local art stores.

Glossary

Armature: A framework built as a support for a sculpted figure

Cast: To pour a liquid such as bronze, plaster, or porcelain into a mold until it hardens

Contour: The center, innermost part of the sculpture

Cure: Heating to promote hardening

Glaze: To cover with a glossy coating, or to highly polish

Kiln (pronounced kil or kiln): A furnace for firing or drying terra-cotta, stoneware, and porcelain

Malleable: Capable of being shaped

Mass: The main body of the sculpture

Plasticity: The capability of a clay to move well while being sculpted

Proportion: The proper relation between parts

Score: Line cut into the surface of the clay

Surface detail: Design added to the surface of a sculpture

Symmetry: Equal form on opposite sides

Tactile: Regarding the sense of touch

Three-dimensional: Having depth, width, and height

Whittle: To carve on wood

Bibliography

Brande, Jacob M., *Lifetime Speakers Encyclopedia* (Prentice-Hall)

Dive into Sea World (Sea World)

Henri, Robert, *Art Spirit* (Harper & Row).

Murray, Edward F., *Crown Treasury of Relevant Quotations* (Crown Publishers)

Prew, Clive, *VW Beetle* (Mallard Press)

Van Gogh, Vincent, *Dear Theo* (Doubleday)

INDEX

Publisher's Note

Additional copies of *Hands on Sculpting* may be purchased at your local bookstore, or direct from Columbine Communications & Publications by sending your check or money order for $19.95, plus $3.00 postage and handling (California residents add 7 1/2% sales tax) to: Columbine Communications & Publications, 1293 E. Barcus Way, Fortuna, CA 95540.

Attention: Schools and Corporations

Hands on Sculpting and other books from Columbine Communications & Publications are available at quantity discounts with bulk purchase for educational, business, or sales promotional use. For information, please write: Special Sale Department, Columbine Communications & Publications, 1293 E. Barcus Way, Fortuna, CA 95540.